NICOTEXT

The
Mission

The Legal Text
Look here, dude, this book is ours. We made it, and we own it.
We therefore forbid you to do any of the following with it:
use the pages as toilet paper, use the book as a meal tray,
reproduce any part of this book without written permission from the
Publisher (that would be us).
If you ignore this warning we will get really, really upset with
you. That, and we'll put a snail on your eye while you're
sleeping. So, if you don't want a snail on your eye, do as we say! Now,
lean back and enjoy this here book we put together, just for you.

**DO NOT DRINK AND DRIVE & DO NOT DRINK ALCOHOL
IF YOU ARE UNDER DRINKING AGE!**

...AND KIDS, REMEMBER, ALWAYS WEAR A CONDOM!

The publisher, authors disclaim any liability that may result
from the use of the information contained in this book.

All the information in this book comes directly from experts but we
do not guarantee that the information contained herein is complete
or accurate.

www.nicotext.com
info@nicotext.com

Fredrik Colting
Carl-Johan Gadd

Copyright ©NICOTEXT 2006 All rights reserved
ISBN91-85449-06-7
Printed in Finland

A Word Before

Old kliché:
This is the first day of the rest of your life.

Do you ever feel like each day is and endless repetition of the day before? Like each day floats into the next and soon everyday feels the same? The Mission offers you a way out of this boredom.

What if I turn left here, instead of right? What will happen?
What's around the corner? Who's around the corner?
Life is full of surprises. You just have to be there to catch the opportunities when they fall from the sky.
The Mission points you in the right direction.
Complete one mission per day. Do them all, in whatever order you like, and notice how things start changing around you.

New kliché:
This is the first day of the Mission. Tomorrow nothing will be the same.

1.

Go to a gas station and grab a sponge and bucket. Wash the windows of a random car.

Mission accomplished: ☐

What happened?...

What did it feel like?..

How difficult was this mission:

A piece of cake: ☐ Hard: ☐ Impossible: ☐

2.

Treat a stranger to the movies.

Mission accomplished: ☐

What happened?...

What did it feel like?..

How difficult was this mission:

A piece of cake: ☐ Hard: ☐ Impossible: ☐

3.

Go to the nearest coffee shop. "Accidently" spill coffee on someone sitting alone. Offer to buy them another cup of coffee.

Mission accomplished: ☐

What happened?...

What did it feel like?..

How difficult was this mission:

A piece of cake: ☐ Hard: ☐ Impossible: ☐

4.

Cut your hair in a fashion you've never worn before.

Mission accomplished: ☐

What happened?...

What did it feel like?..

How difficult was this mission:

A piece of cake: ☐ Hard: ☐ Impossible: ☐

5.

Arrange a dinner for six strangers. Find five people that have never met. Invite them all to your house for dinner next weekend.

Mission accomplished: ☐

What happened?...

What did it feel like?...

How difficult was this mission:

A piece of cake: ☐ Hard: ☐ Impossible: ☐

6.

Smack a stranger on the ass.

Mission accomplished: ☐

What happened?...

What did it feel like?...

How difficult was this mission:

A piece of cake: ☐ Hard: ☐ Impossible: ☐

7.
Go alone to a movie.
See whatever is running in Cinema 2.

Mission accomplished: ☐

What happened?..

What did it feel like?..

How difficult was this mission:

A piece of cake: ☐ Hard: ☐ Impossible: ☐

8.
Do a search on your own name on the internet. Call, write or e-mail the person sharing your name who lives the farthest from you.

Mission accomplished: ☐

What happened?..

What did it feel like?..

How difficult was this mission:

A piece of cake: ☐ Hard: ☐ Impossible: ☐

9.
Go to the library.
Search for writers with your name.
Read the first book that comes up,
no matter what it's about.

Mission accomplished: ☐

What happened?..

What did it feel like?..

How difficult was this mission:

A piece of cake: ☐ Hard: ☐ Impossible: ☐

10.
Learn a poem by heart.

Mission accomplished: ☐

What happened?..

What did it feel like?..

How difficult was this mission:

A piece of cake: ☐ Hard: ☐ Impossible: ☐

11.

While sitting on the toilet, drink a glass of water at the exact same moment as you pee.

Mission accomplished: ☐

What happened?..

What did it feel like?...

How difficult was this mission:

A piece of cake: ☐ Hard: ☐ Impossible: ☐

12.

Pet five different dogs today, and learn their names. Write them down in your address book.

Mission accomplished: ☐

What happened?..

What did it feel like?...

How difficult was this mission:

A piece of cake: ☐ Hard: ☐ Impossible: ☐

13.

Go to the drama section of the videostore. Pick the movie on the second row from the top, the seventh from the left. Watch it and learn one line by heart.

Mission accomplished: ☐

What happened?..

What did it feel like?..

How difficult was this mission:

A piece of cake: ☐ Hard: ☐ Impossible: ☐

14.

Steal something from your best friend.

Mission accomplished: ☐

What happened?..

What did it feel like?..

How difficult was this mission:

A piece of cake: ☐ Hard: ☐ Impossible: ☐

The helpful Page!

Hiphop
Hiphop

Kvackkvackkvack

Frrrrt frrrt frrrt

Don't be a sucker in
the woods. Learn to
imitate these birds.

Hey ho
let's go

Boom
chacka
boom

15.

Go to the nearest newsstand. Buy a pack of gum and walk back, like a movie played backwards.

Mission accomplished: ☐

What happened?..

What did it feel like?...

How difficult was this mission:

A piece of cake: ☐ **Hard:** ☐ **Impossible:** ☐

16.

Eat a raw clove of garlic.

Mission accomplished: ☐

What happened?..

What did it feel like?...

How difficult was this mission:

A piece of cake: ☐ **Hard:** ☐ **Impossible:** ☐

17.
Bring an apple to your teacher or boss.

Mission accomplished: ☐

What happened?...

What did it feel like?...

How difficult was this mission:

A piece of cake: ☐ Hard: ☐ Impossible: ☐

18.
Get in touch with someone from elementary school. Suggest a meeting. Say you saw it in a dream.

Mission accomplished: ☐

What happened?...

What did it feel like?...

How difficult was this mission:

A piece of cake: ☐ Hard: ☐ Impossible: ☐

19.

Borrow two eggs from your neighbour.
Borrow 2 cups of sugar from another.
Borrow 3 cups of flour and 2 tsp
baking powder from a third.
Borrow a pint of milk from a fourth.
Bake a sponge cake and offer some
to each of your neighbours.

Mission accomplished: ☐

What happened?..

What did it feel like?...

How difficult was this mission:

A piece of cake: ☐ Hard: ☐ Impossible: ☐

20.

Pay $ 2.50 to bank account nr: 46300106865 - wait for a surprise.

Mission accomplished: ☐

What happened?...

What did it feel like?..

How difficult was this mission:

A piece of cake: ☐ Hard: ☐ Impossible: ☐

21.

Go to the grocery store with a banana peel. Tell them you'd like to exchange it cause when you opened it, it was empty.

Mission accomplished: ☐

What happened?...

What did it feel like?..

How difficult was this mission:

A piece of cake: ☐ Hard: ☐ Impossible: ☐

What I want for Christmas:

22.

If you're a girl, wear men's underwear all day. If you're a guy, wear panties all day.

Mission accomplished: ☐

What happened?..

What did it feel like?...

How difficult was this mission:

A piece of cake: ☐　　　Hard: ☐　　　Impossible: ☐

23.

Borrow money from a stranger.

Mission accomplished: ☐

What happened?..

What did it feel like?...

How difficult was this mission:

A piece of cake: ☐　　　Hard: ☐　　　Impossible: ☐

24.

Book a trip to a country far, far away. If you can't afford to go, just cancel it tomorrow.

Mission accomplished: ☐

What happened?..

What did it feel like?...

How difficult was this mission:

A piece of cake: ☐ Hard: ☐ Impossible: ☐

25.

Do ten push-ups on line at the nearest McDonalds.

Mission accomplished: ☐

What happened?..

What did it feel like?...

How difficult was this mission:

A piece of cake: ☐ Hard: ☐ Impossible: ☐

26.

Eat ice cream really fast, until you get an ice cream headache.
Do this two consecutive times.

Mission accomplished: ☐

What happened?...

What did it feel like?...

How difficult was this mission:

A piece of cake: ☐ Hard: ☐ Impossible: ☐

27.

Count all the red Chevrolet Explorers you see today.

Mission accomplished: ☐

What happened?...

What did it feel like?...

How difficult was this mission:

A piece of cake: ☐ Hard: ☐ Impossible: ☐

28.

Write a letter to yourself about what you think will happen tomorrow. Post it and see if your were right.

Mission accomplished: ☐

What happened?...

What did it feel like?..

How difficult was this mission:

A piece of cake: ☐ Hard: ☐ Impossible: ☐

29.

Pee outside today, sometime between 7.00 and 10.00. am

Mission accomplished: ☐

What happened?...

What did it feel like?..

How difficult was this mission:

A piece of cake: ☐ Hard: ☐ Impossible: ☐

30.

At the supermarket, collect a whole cart filled with just one product. When it's your turn to pay, pretend to have forgotten your wallet and excuse yourself.

Mission accomplished: ☐

What happened?..

What did it feel like?...

How difficult was this mission:

A piece of cake: ☐ Hard: ☐ Impossible: ☐

31.
Ride in a police car.

Mission accomplished: ☐

What happened?..

What did it feel like?...

How difficult was this mission:

A piece of cake: ☐ Hard: ☐ Impossible: ☐

32.
Go to an electronics store. Turn the volume up to maximum on a stereo, and leave.

Mission accomplished: ☐

What happened?..

What did it feel like?...

How difficult was this mission:

A piece of cake: ☐ Hard: ☐ Impossible: ☐

33.
Pick something up out of a garbage can and get someone to eat it.

Mission accomplished: ☐

What happened?..

What did it feel like?...

How difficult was this mission:

A piece of cake: ☐ Hard: ☐ Impossible: ☐

34.

Try to sell your best friend. Make a sign that says "Best friend for sale - $ 25", and go stand in a public place. Split the money with your friend.

Mission accomplished: ☐

What happened?..

What did it feel like?..

How difficult was this mission:

A piece of cake: ☐ Hard: ☐ Impossible: ☐

35.
Cut ahead in a line.

Mission accomplished: ☐

What happened?..

What did it feel like?..

How difficult was this mission:

A piece of cake: ☐ Hard: ☐ Impossible: ☐

36.

Write "I love you" on a piece of paper, along with your phone number. Stick the note in a stranger's pocket.

Mission accomplished: ☐

What happened?..

What did it feel like?..

How difficult was this mission:

A piece of cake: ☐ Hard: ☐ Impossible: ☐

37.

Learn all the capitals of Africa.

Mission accomplished: ☐

What happened?..

What did it feel like?..

How difficult was this mission:

A piece of cake: ☐ Hard: ☐ Impossible: ☐

38.

As long as it's daylight, wear your left shoe on your right foot, and the other way around once the sun goes down.

Mission accomplished: ☐

What happened?...

What did it feel like?...

How difficult was this mission:

A piece of cake: ☐ Hard: ☐ Impossible: ☐

39.

Today, you are only allowed to eat things that start with a P, S or a T.

Mission accomplished: ☐

What happened?...

What did it feel like?...

How difficult was this mission:

A piece of cake: ☐ Hard: ☐ Impossible: ☐

40.

Ask an old man or woman about the meaning of life. Ask a kid the same thing.

Mission accomplished: ☐

What happened?...

What did it feel like?..

How difficult was this mission:

A piece of cake: ☐ Hard: ☐ Impossible: ☐

41.

Learn one yoga posture.

Mission accomplished: ☐

What happened?...

What did it feel like?..

How difficult was this mission:

A piece of cake: ☐ Hard: ☐ Impossible: ☐

Important phone numbers:

Wall Street: 212-656-3000
NASA: 202-358-0000
Swedish Royal Castle: +46 8-4026130
The White House: 202-456-1414
The Pentagon: 703-428-0711
Graceland: 901-332-3322
The Heinz Ketchup Factory: 201-329-8660
McDonald's in Oman: +968 701-454
The French Foreign Legion:
+33 148-774-968
The Great Wall of China:
+86 791-620-6666
The Vatican: +39 (6)698-835-11

42.

Eat French food for breakfast, Chinese food for lunch and Italian food for dinner.

Mission accomplished: ☐

What happened?...

What did it feel like?...

How difficult was this mission:

A piece of cake: ☐ Hard: ☐ Impossible: ☐

43.

Try to get someone to stop smoking.

Mission accomplished: ☐

What happened?...

What did it feel like?...

How difficult was this mission:

A piece of cake: ☐ Hard: ☐ Impossible: ☐

44.
Play the Lotto. Order coffee at a coffee shop and offer to pay for it with half of what you win.

Mission accomplished: ☐

What happened?...

What did it feel like?..

How difficult was this mission:

A piece of cake: ☐ Hard: ☐ Impossible: ☐

45.
Fall where people can see you.

Mission accomplished: ☐

What happened?...

What did it feel like?..

How difficult was this mission:

A piece of cake: ☐ Hard: ☐ Impossible: ☐

46.

Eat dinner food for breakfast and breakfast food for dinner.

Mission accomplished: ☐

What happened?..

What did it feel like?..

How difficult was this mission:

A piece of cake: ☐ Hard: ☐ Impossible: ☐

47.

Think about something that upsets you and scream at the top of your lungs for one minute.

Mission accomplished: ☐

What happened?..

What did it feel like?..

How difficult was this mission:

A piece of cake: ☐ Hard: ☐ Impossible: ☐

48.

At 4.00pm today, drop whatever you are doing. Sit down on a chair and close your eyes. Spend the next 10 minutes noticing your breathing.

Mission accomplished: ☐

What happened?..

What did it feel like?...

How difficult was this mission:

A piece of cake: ☐ Hard: ☐ Impossible: ☐

49.

Write your will.

Mission accomplished: ☐

What happened?..

What did it feel like?...

How difficult was this mission:

A piece of cake: ☐ Hard: ☐ Impossible: ☐

50.
Paint a picture and send it to the nearest art gallery, along with your name and number.

Mission accomplished: ☐

What happened?...

What did it feel like?...

How difficult was this mission:

A piece of cake: ☐ Hard: ☐ Impossible: ☐

51.
Pet a cow.

Mission accomplished: ☐

What happened?...

What did it feel like?...

How difficult was this mission:

A piece of cake: ☐ Hard: ☐ Impossible: ☐

52.

Call a distant relative that you haven't spoken to in at least one year. Steer the conversation to Korea.

Mission accomplished: ☐

What happened?..

What did it feel like?..

How difficult was this mission:

A piece of cake: ☐ Hard: ☐ Impossible: ☐

53.

Eat a standard sized piece of office paper.

Mission accomplished: ☐

What happened?..

What did it feel like?..

How difficult was this mission:

A piece of cake: ☐ Hard: ☐ Impossible: ☐

54.
Today, stand on one leg whenever your waiting to cross the street.

Mission accomplished: ☐

What happened?..

What did it feel like?...

How difficult was this mission:

A piece of cake: ☐ Hard: ☐ Impossible: ☐

55.
Start and spread a rumor.

Mission accomplished: ☐

What happened?..

What did it feel like?...

How difficult was this mission:

A piece of cake: ☐ Hard: ☐ Impossible: ☐

56.
Touch an electric fence.

Mission accomplished: ☐

What happened?..

What did it feel like?...

How difficult was this mission:

A piece of cake: ☐ Hard: ☐ Impossible: ☐

57.
Buy something that costs at least $10. Pay with nothing but quarters.

Mission accomplished: ☐

What happened?..

What did it feel like?...

How difficult was this mission:

A piece of cake: ☐ Hard: ☐ Impossible: ☐

58.
Live today without spending a single dollar.

Mission accomplished: ☐

What happened?..

What did it feel like?...

How difficult was this mission:

A piece of cake: ☐ Hard: ☐ Impossible: ☐

59.
Buy a burger at McDonalds. Go to Burger King to eat it.

Mission accomplished: ☐

What happened?..

What did it feel like?...

How difficult was this mission:

A piece of cake: ☐ Hard: ☐ Impossible: ☐

60.
Speak Pig Latin for the first five minutes of every hour.

Mission accomplished: ☐

What happened?...

What did it feel like?...

How difficult was this mission:

A piece of cake: ☐ Hard: ☐ Impossible: ☐

61.
Call someone in Corpus Christi.

Mission accomplished: ☐

What happened?...

What did it feel like?...

How difficult was this mission:

A piece of cake: ☐ Hard: ☐ Impossible: ☐

Plan the perfect crime!

62.

Start counting, and see how far you'll get in half-an-hour.

Mission accomplished: ☐

What happened?..

What did it feel like?..

How difficult was this mission:

A piece of cake: ☐ Hard: ☐ Impossible: ☐

63.

Watch a movie that starts with an R.

Mission accomplished: ☐

What happened?..

What did it feel like?..

How difficult was this mission:

A piece of cake: ☐ Hard: ☐ Impossible: ☐

64.
Wear a bathrobe and rubber boots when you do your grocery shopping today.

Mission accomplished: ☐

What happened?..

What did it feel like?..

How difficult was this mission:

A piece of cake: ☐ Hard: ☐ Impossible: ☐

65.
Swim 25 meters under water.

Mission accomplished: ☐

What happened?..

What did it feel like?..

How difficult was this mission:

A piece of cake: ☐ Hard: ☐ Impossible: ☐

66.
Kick a ball all the way from your house to your school/work.

Mission accomplished: ☐

What happened?..

What did it feel like?..

How difficult was this mission:

A piece of cake: ☐ Hard: ☐ Impossible: ☐

67.
Walk backwards over all street crossings today.

Mission accomplished: ☐

What happened?..

What did it feel like?..

How difficult was this mission:

A piece of cake: ☐ Hard: ☐ Impossible: ☐

68.
Pretend to have lost your voice. Say nothing all day. Use a pen and paper to communicate.

Mission accomplished: ☐

What happened?...

What did it feel like?..

How difficult was this mission:

A piece of cake: ☐ Hard: ☐ Impossible: ☐

69.
Play Rock, Paper, Scissors with a stranger.

Mission accomplished: ☐

What happened?...

What did it feel like?..

How difficult was this mission:

A piece of cake: ☐ Hard: ☐ Impossible: ☐

70.
Today, say "BANG" everytime you see a watch.

Mission accomplished: ☐

What happened?..

What did it feel like?..

How difficult was this mission:

A piece of cake: ☐ Hard: ☐ Impossible: ☐

71.
Sell something.

Mission accomplished: ☐

What happened?..

What did it feel like?..

How difficult was this mission:

A piece of cake: ☐ Hard: ☐ Impossible: ☐

Your Pornstar Name

=take the name of your first pet and combine
with the name of the first street you lived on

Some other good pornstar names:

Adam Wild, Ashley Foxx, Betty Boobs, Biff Malibu,
Misty Devine, Nikki Diamonds, Kate Kaptive,
Coco la Rocco, Arthur Dix, Vanilla Venus, Randy Ravage

72.

Write your name and phone
number on a piece of paper,
stick it in a bottle and put it in
the nearest river, sea or lake.

Mission accomplished: ☐

What happened?...

What did it feel like?...

How difficult was this mission:

A piece of cake: ☐ Hard: ☐ Impossible: ☐

73.

Buy a big bag of candy, but only
candy colored pink, blue and white.

Mission accomplished: ☐

What happened?...

What did it feel like?...

How difficult was this mission:

A piece of cake: ☐ Hard: ☐ Impossible: ☐

74.

Paint a picture and sneak it into the nearest museum. Lean it against a wall like it's part of the exhibition.

Mission accomplished: ☐

What happened?..

What did it feel like?..

How difficult was this mission:

A piece of cake: ☐ Hard: ☐ Impossible: ☐

75.

Take a picture of someone famous.

Mission accomplished: ☐

What happened?..

What did it feel like?..

How difficult was this mission:

A piece of cake: ☐ Hard: ☐ Impossible: ☐

76.

Order a taxi and go from one side of the street to the other.

Mission accomplished: ☐

What happened?...

What did it feel like?...

How difficult was this mission:

A piece of cake: ☐ Hard: ☐ Impossible: ☐

77.

Eat in a restaurant and offer to pay by doing dishes.

Mission accomplished: ☐

What happened?...

What did it feel like?...

How difficult was this mission:

A piece of cake: ☐ Hard: ☐ Impossible: ☐

78.

Go to the nearest parking area. Find a car where the meter has run out. Pay for 1 hour and put the receipt under the window wiper.

Mission accomplished: ☐

What happened?..

What did it feel like?..

How difficult was this mission:

A piece of cake: ☐ Hard: ☐ Impossible: ☐

79.

Invent a new dish.

Mission accomplished: ☐

What happened?..

What did it feel like?..

How difficult was this mission:

A piece of cake: ☐ Hard: ☐ Impossible: ☐

80.

When signing things today, use your left hand if you're right handed, and the other way around.

Mission accomplished: ☐

What happened?..

What did it feel like?..

How difficult was this mission:

A piece of cake: ☐ Hard: ☐ Impossible: ☐

81.

Get bitten by an animal.

Mission accomplished: ☐

What happened?..

What did it feel like?..

How difficult was this mission:

A piece of cake: ☐ Hard: ☐ Impossible: ☐

82.
Use a phony moustache during lunch.

Mission accomplished: ☐

What happened?..

What did it feel like?..

How difficult was this mission:

A piece of cake: ☐ Hard: ☐ Impossible: ☐

83.
Go to, at least, two house or apartment open houses.

Mission accomplished: ☐

What happened?..

What did it feel like?..

How difficult was this mission:

A piece of cake: ☐ Hard: ☐ Impossible: ☐

84.

Find and go to the nearest sauna. Start a conversation about the weather or TV.

Mission accomplished: ☐

What happened?..

What did it feel like?..

How difficult was this mission:

A piece of cake: ☐ Hard: ☐ Impossible: ☐

85.

Give someone older than fifty a backrub.

Mission accomplished: ☐

What happened?..

What did it feel like?..

How difficult was this mission:

A piece of cake: ☐ Hard: ☐ Impossible: ☐

86.
Get five strangers to take a piece of candy from a bag of candy.

Mission accomplished: ☐

What happened?..

What did it feel like?..

How difficult was this mission:

A piece of cake: ☐ Hard: ☐ Impossible: ☐

87.
Start learning judo or badminton.

Mission accomplished: ☐

What happened?..

What did it feel like?..

How difficult was this mission:

A piece of cake: ☐ Hard: ☐ Impossible: ☐

88.
Stalk a stranger for at least one hour. Follow their every step but make sure you're not seen.

Mission accomplished: ☐

What happened?...

What did it feel like?...

How difficult was this mission:

A piece of cake: ☐ Hard: ☐ Impossible: ☐

89.
Arrange a snail or turtle race.

Mission accomplished: ☐

What happened?...

What did it feel like?...

How difficult was this mission:

A piece of cake: ☐ Hard: ☐ Impossible: ☐

90.

As soon as you get up in the morning, grab a die. Roll it.

1 = Roll again
2 = Stay home from school/work
3 = Buy a pet
4 = Arrange a pie eating contest
5 = Buy a copy of Mission
and give it to a friend
6 = See the movie "Flashdance"

Mission accomplished: ☐

What happened?...

What did it feel like?...

How difficult was this mission:

A piece of cake: ☐ Hard: ☐ Impossible: ☐

Alien Insurance

This really, really good insurance will pay you $1 million if
you're unlucky (or lucky) enough to be abducted by aliens.
Upon your return, just show your insurance company this note
and you should have your money within a couple of days.
Conversational topics, if you're abducted:

-It sure is hard finding one-eyed glasses.
-You know, E.T. is my absolute, favorite movie.

-Human meat is very fattening.

The helpful Page!

91.
Call someone with the same phone number as you, but with a different area-code. Talk until you find common ground.

Mission accomplished: ☐

What happened?..

What did it feel like?...

How difficult was this mission:

A piece of cake: ☐ Hard: ☐ Impossible: ☐

92.
Climb a tree.

Mission accomplished: ☐

What happened?..

What did it feel like?...

How difficult was this mission:

A piece of cake: ☐ Hard: ☐ Impossible: ☐

93.
Walk someone else's dog.

Mission accomplished: ☐

What happened?...

What did it feel like?...

How difficult was this mission:

A piece of cake: ☐ Hard: ☐ Impossible: ☐

94.
Eat Chinese for dinner.
Choose between dishes
22, 43 and 69.

Mission accomplished: ☐

What happened?...

What did it feel like?...

How difficult was this mission:

A piece of cake: ☐ Hard: ☐ Impossible: ☐

95.
Pick up at least ten pieces of garbage from the street today.

Mission accomplished: ☐

What happened?..

What did it feel like?..

How difficult was this mission:

A piece of cake: ☐ Hard: ☐ Impossible: ☐

96.
Eat or drink something that's older than yourself.

Mission accomplished: ☐

What happened?..

What did it feel like?..

How difficult was this mission:

A piece of cake: ☐ Hard: ☐ Impossible: ☐

97.
Set all your clocks and watches one hour ahead and live as that was the "real" time.

Mission accomplished: ☐

What happened?...

What did it feel like?...

How difficult was this mission:

A piece of cake: ☐ Hard: ☐ Impossible: ☐

98.
Carry a raw egg with you today, all day, without braking it.

Mission accomplished: ☐

What happened?...

What did it feel like?...

How difficult was this mission:

A piece of cake: ☐ Hard: ☐ Impossible: ☐

99.
Send an anonymous "I like you" note to your senator (find him at www.senate.gov)

Mission accomplished: ☐

What happened?..

What did it feel like?...

How difficult was this mission:

A piece of cake: ☐ Hard: ☐ Impossible: ☐

100.
Today, eat only fruit.

Mission accomplished: ☐

What happened?..

What did it feel like?...

How difficult was this mission:

A piece of cake: ☐ Hard: ☐ Impossible: ☐

101.
Go to the movies.
Get a seat in one of the back rows.
Walk all the rows down towards
the screen, in a zig-zag pattern,
making everyone get up as
you want to pass.

Mission accomplished: ☐

What happened?..

What did it feel like?..

How difficult was this mission:

A piece of cake: ☐ Hard: ☐ Impossible: ☐

BLING BLING

Business idea!
This is how I'm gonna make my first million:

102.
Write "Call me" and your phone number on all the dollar bills you use today.

Mission accomplished: ☐

What happened?...

What did it feel like?...

How difficult was this mission:

A piece of cake: ☐ Hard: ☐ Impossible: ☐

103.
Sleep all night on the floor, next to your bed.

Mission accomplished: ☐

What happened?...

What did it feel like?...

How difficult was this mission:

A piece of cake: ☐ Hard: ☐ Impossible: ☐

104.

Go to the nearest museum. Go into the second room to your left and stand in front of the fourth painting to the right. Stare at it for one hour.

Mission accomplished: ☐

What happened?..

What did it feel like?...

How difficult was this mission:

A piece of cake: ☐ Hard: ☐ Impossible: ☐

105.
Donate blood.

Mission accomplished: ☐

What happened?..

What did it feel like?...

How difficult was this mission:

A piece of cake: ☐ Hard: ☐ Impossible: ☐

106.
Design and draw your own stamp. Send it to:
United States Postal Service
475 Lenfant Plz SW Ste 2340
Washington, D.C. 20260-2340

Mission accomplished: ☐

What happened?..

What did it feel like?...

How difficult was this mission:

A piece of cake: ☐ Hard: ☐ Impossible: ☐

107.
Wake someone who's sleeping.

Mission accomplished: ☐

What happened?..

What did it feel like?...

How difficult was this mission:

A piece of cake: ☐ Hard: ☐ Impossible: ☐

108.

Set up a meeting with someone, at a specific place, in exact one year.

Mission accomplished: ☐

What happened?..

What did it feel like?..

How difficult was this mission:

A piece of cake: ☐ Hard: ☐ Impossible: ☐

109.

Write a letter to your future self. Mark the letter "Don't open until (pick a date)". Hide it in a cabinet.

Mission accomplished: ☐

What happened?..

What did it feel like?..

How difficult was this mission:

A piece of cake: ☐ Hard: ☐ Impossible: ☐

110.
Get ten strangers to jump,
as you take a picture of them.

Mission accomplished: ☐

What happened?..

What did it feel like?...

How difficult was this mission:

A piece of cake: ☐ Hard: ☐ Impossible: ☐

111.
Sort your CDs alphabetically.

Mission accomplished: ☐

What happened?..

What did it feel like?...

How difficult was this mission:

A piece of cake: ☐ Hard: ☐ Impossible: ☐

112.
Use white chalk and mark the street every thirty feet, everywhere you go today.

Mission accomplished: ☐

What happened?..

What did it feel like?...

How difficult was this mission:

A piece of cake: ☐ Hard: ☐ Impossible: ☐

113.
Lie about five different things today.

Mission accomplished: ☐

What happened?..

What did it feel like?...

How difficult was this mission:

A piece of cake: ☐ Hard: ☐ Impossible: ☐

Draw a picture

The helpful page

114.

Everytime you go to the bathroom today, sing "Oh when the saints go marching in".

Mission accomplished: ☐

What happened?..

What did it feel like?...

How difficult was this mission:

A piece of cake: ☐ Hard: ☐ Impossible: ☐

115.

Ask a stranger to scratch your back.

Mission accomplished: ☐

What happened?..

What did it feel like?...

How difficult was this mission:

A piece of cake: ☐ Hard: ☐ Impossible: ☐

116.
Today you can only turn left. That means, if you want to turn right you have to turn left, then left again, then left again, all way around.

Mission accomplished: ☐

What happened?..

What did it feel like?..

How difficult was this mission:

A piece of cake: ☐ Hard: ☐ Impossible: ☐

117.
Give someone a compliment.

Mission accomplished: ☐

What happened?..

What did it feel like?..

How difficult was this mission:

A piece of cake: ☐ Hard: ☐ Impossible: ☐

118.
Today, everytime you cross a street you need to be holding someones hand. Anyone's.

Mission accomplished: ☐

What happened?...

What did it feel like?...

How difficult was this mission:

A piece of cake: ☐ Hard: ☐ Impossible: ☐

119.
Throw away something you really like.

Mission accomplished: ☐

What happened?...

What did it feel like?...

How difficult was this mission:

A piece of cake: ☐ Hard: ☐ Impossible: ☐

120.
Today, instead of using the word "Hello", use the word "Yo".

Mission accomplished: ☐

What happened?...

What did it feel like?...

How difficult was this mission:

A piece of cake: ☐ Hard: ☐ Impossible: ☐

121.
Introduce yourself to a neighbor you've never said hello to.

Mission accomplished: ☐

What happened?...

What did it feel like?...

How difficult was this mission:

A piece of cake: ☐ Hard: ☐ Impossible: ☐

122.
Write down the title and the first line of the book you'll one day write.

Mission accomplished: ☐

What happened?...

What did it feel like?..

How difficult was this mission:

A piece of cake: ☐ Hard: ☐ Impossible: ☐

123.
Today you're not allowed to use the words "Yes" or "No".

Mission accomplished: ☐

What happened?...

What did it feel like?..

How difficult was this mission:

A piece of cake: ☐ Hard: ☐ Impossible: ☐

124.

Decide what your last meal would be if you where to die tomorrow. Make it for dinner.

Mission accomplished: ☐

What happened?..

What did it feel like?..

How difficult was this mission:

A piece of cake: ☐ Hard: ☐ Impossible: ☐

125.

Walk barefoot accross a piece of grass.

Mission accomplished: ☐

What happened?..

What did it feel like?..

How difficult was this mission:

A piece of cake: ☐ Hard: ☐ Impossible: ☐

126.
Go to the sea.

Mission accomplished: ☐

What happened?..

What did it feel like?..

How difficult was this mission:

A piece of cake: ☐ Hard: ☐ Impossible: ☐

127.
Today, chew every bite of food at least fifteen times before swallowing.

Mission accomplished: ☐

What happened?..

What did it feel like?..

How difficult was this mission:

A piece of cake: ☐ Hard: ☐ Impossible: ☐

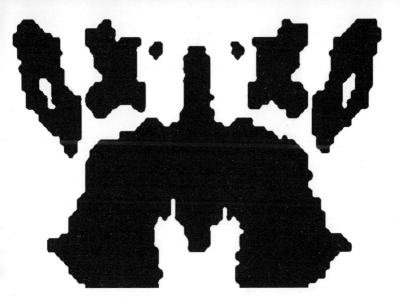

Rorshachs Test
What do you see?

..

..

..

..

..

..

..

..

..

..

128.
This is what you'll watch on TV tonight:

6:20 – 6:45 Channel 3
6:45 – 7:05 Channel 9
7:05 – 7:50 Channel 5

7:50 – 8:00 bathroom break

8:10 – 8:25 Channel 11
8:25 – 9:12 Channel 4
9:12 – 10:05 Channel 13

Mission accomplished: ☐

What happened?..

What did it feel like?..

How difficult was this mission:

A piece of cake: ☐ Hard: ☐ Impossible: ☐

129.

Get your picture taken in a photobooth. Make the worst faces you possibly can. Send the photos to:
Internal Revenue Service
1111 20th Street North West
Washington, D.C. 20526

Mission accomplished: ☐

What happened?..

What did it feel like?...

How difficult was this mission:

A piece of cake: ☐ Hard: ☐ Impossible: ☐

130.
Make a baked Alaska.

Mission accomplished: ☐

What happened?..

What did it feel like?...

How difficult was this mission:

A piece of cake: ☐ Hard: ☐ Impossible: ☐

131.
Watch a sunset with someone you like.

Mission accomplished: ☐

What happened?...

What did it feel like?..

How difficult was this mission:

A piece of cake: ☐ Hard: ☐ Impossible: ☐

132.
If you're a smoker, don't smoke anything today. If you're a non-smoker, smoke regulary throughout the day.

Mission accomplished: ☐

What happened?...

What did it feel like?..

How difficult was this mission:

A piece of cake: ☐ Hard: ☐ Impossible: ☐

133.

Cross the street as soon as someone you meet gives you eye contact.

Mission accomplished: ☐

What happened?..

What did it feel like?...

How difficult was this mission:

A piece of cake: ☐ Hard: ☐ Impossible: ☐

134.

Hold the elevator door for someone, carry someone's books, tie someone's shoe laces, and rub someone's back.

Mission accomplished: ☐

What happened?..

What did it feel like?...

How difficult was this mission:

A piece of cake: ☐ Hard: ☐ Impossible: ☐

135.

**Dial a random phone number and say:
"The grass isn't greener on the other
side, but warm, oh so warm.
Let this be a lesson.". Hang up.**

Mission accomplished: ☒

What happened?..woman answered + thought it was a bible study

What did it feel like?..humerous

How difficult was this mission:

A piece of cake: ☒ Hard: ☐ Impossible: ☐

136.

Sing, at least one hymn in church.

Mission accomplished: ☐

What happened?..

What did it feel like?...

How difficult was this mission:

A piece of cake: ☐ Hard: ☐ Impossible: ☐

Write down the capitals of all the countries in Africa.

Things to keep in mind:
The time difference, malaria mosquitoes and tribal wars.

The helpful Page!

137.
Pick a flower and give it to your mother.

Mission accomplished: ☐

What happened?...

What did it feel like?...

How difficult was this mission:

A piece of cake: ☐ Hard: ☐ Impossible: ☐

138.
Send a letter, with a picture of yourself, to a randomly picked address. Include two one dollar bills.

Mission accomplished: ☐

What happened?...

What did it feel like?...

How difficult was this mission:

A piece of cake: ☐ Hard: ☐ Impossible: ☐

139.
Find out, and write down, your ten closest friends' birthdays.

Mission accomplished: ☐

What happened?..

What did it feel like?..

How difficult was this mission:

A piece of cake: ☐ Hard: ☐ Impossible: ☐

140.
Plant an apple or a pear in a park near you.

Mission accomplished: ☐

What happened?..

What did it feel like?..

How difficult was this mission:

A piece of cake: ☐ Hard: ☐ Impossible: ☐

141.
Break a mirror, walk under a ladder, open an umbrella indoors, let a black cat cross the road in front of you.

Mission accomplished: ☐

What happened?..

What did it feel like?..

How difficult was this mission:

A piece of cake: ☐ Hard: ☐ Impossible: ☐

142.
Write a quote for your gravestone.

Mission accomplished: ☐

What happened?..

What did it feel like?..

How difficult was this mission:

A piece of cake: ☐ Hard: ☐ Impossible: ☐

143.
Live two hours as blind. Cover your eyes and have a friend guide you around.

Mission accomplished: ☐

What happened?..

What did it feel like?..

How difficult was this mission:

A piece of cake: ☐ Hard: ☐ Impossible: ☐

144.
Today, read all newspapers upside-down.

Mission accomplished: ☐

What happened?..

What did it feel like?..

How difficult was this mission:

A piece of cake: ☐ Hard: ☐ Impossible: ☐

145.
Try to get something to levitate. Stare at something really hard for 15 minutes.

Mission accomplished: ☐

What happened?...

What did it feel like?...

How difficult was this mission:

A piece of cake: ☐ Hard: ☐ Impossible: ☐

146.
Read all newspapers in your area.

Mission accomplished: ☐

What happened?...

What did it feel like?...

How difficult was this mission:

A piece of cake: ☐ Hard: ☐ Impossible: ☐

The helpful Page!

Write your speech now so, when you win, you don't have to stand there like a moron, fumbling with a piece of paper.

Name:

147.

Order, and eat, a pizza with ALL of the following toppings: peanuts, asparagus, artichokes, pineapple, anchovis, onion, banana, bacon and mustard.

Mission accomplished: ☐

What happened?...

What did it feel like?..

How difficult was this mission:

A piece of cake: ☐ Hard: ☐ Impossible: ☐

148.

Read fifty random pages from the Bible.

Mission accomplished: ☐

What happened?...

What did it feel like?..

How difficult was this mission:

A piece of cake: ☐ Hard: ☐ Impossible: ☐

149.
Keep your fly open during lunch today.

Mission accomplished: ☐

What happened?..

What did it feel like?..

How difficult was this mission:

A piece of cake: ☐ Hard: ☐ Impossible: ☐

150.
Fill out five Lotto forms without actually paying for them. Remember to check to see if you would have won.

Mission accomplished: ☐

What happened?..

What did it feel like?..

How difficult was this mission:

A piece of cake: ☐ Hard: ☐ Impossible: ☐

151.
All day today, use earplugs to shut out all noise.

Mission accomplished: ☐

What happened?..

What did it feel like?..

How difficult was this mission:

A piece of cake: ☐ Hard: ☐ Impossible: ☐

152.
Today you can only walk in a goosestep.

Mission accomplished: ☐

What happened?..

What did it feel like?..

How difficult was this mission:

A piece of cake: ☐ Hard: ☐ Impossible: ☐

153.
Be a tourist in your own city.
Visit museums, statues,
monuments and sights.

Mission accomplished: ☐

What happened?..

What did it feel like?..

How difficult was this mission:

A piece of cake: ☐ Hard: ☐ Impossible: ☐

154.
Wear something purple.

Mission accomplished: ☐

What happened?..

What did it feel like?..

How difficult was this mission:

A piece of cake: ☐ Hard: ☐ Impossible: ☐

155.

Take a bus or a train that departs 08.12
(or the closest to it), or 5:04
(or the closest to it).
Get off by the 5th stop.
Walk two blocks north and enter
the nearest coffee-shop.
Have a cup of green tea.

Mission accomplished: ☐

What happened?...

What did it feel like?...

How difficult was this mission:

A piece of cake: ☐ Hard: ☐ Impossible: ☐

156.
Make a suggestion to naming a street after you (your name here) --Street. Send your proposal to your mayor or Board of Selectman.

Mission accomplished: ☐

What happened?..

What did it feel like?..

How difficult was this mission:

A piece of cake: ☐ Hard: ☐ Impossible: ☐

157.
Get yourself a mentor.

Mission accomplished: ☐

What happened?..

What did it feel like?..

How difficult was this mission:

A piece of cake: ☐ Hard: ☐ Impossible: ☐

158.

Write down the dream you had last nights on a postcard. Send it, along with your name, to:
Knopf Publishing, 1745 Broadway
New York, NY 10019

Mission accomplished: ☐

What happened?..

What did it feel like?..

How difficult was this mission:

A piece of cake: ☐ Hard: ☐ Impossible: ☐

159.
Propose to a stranger.

Mission accomplished: ☐

What happened?..

What did it feel like?..

How difficult was this mission:

A piece of cake: ☐ Hard: ☐ Impossible: ☐

160.

Keep a count of all the advertisements you see during the day, including television commercials, magazine ads, signs and billboards, etc.

Mission accomplished: ☐

What happened?...

What did it feel like?..

How difficult was this mission:

A piece of cake: ☐ Hard: ☐ Impossible: ☐

161.

Eat all today's meals with chopsticks.

Mission accomplished: ☐

What happened?...

What did it feel like?..

How difficult was this mission:

A piece of cake: ☐ Hard: ☐ Impossible: ☐

Play Rock-Paper-Scissors. Win every time!

1, 2, 3

1, 2, 3

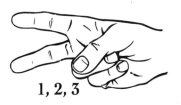

1, 2, 3

1, 2, 3

1, 2, 3

1, 2, 3

The helpful Page!

162.
Stay in bed all day. You may only get up to go to the bathroom and to get something to eat and read.

Mission accomplished: ☐

What happened?...

What did it feel like?...

How difficult was this mission:

A piece of cake: ☐ Hard: ☐ Impossible: ☐

163.
Say "hello" to everyone you meet on the street today.

Mission accomplished: ☐

What happened?...

What did it feel like?...

How difficult was this mission:

A piece of cake: ☐ Hard: ☐ Impossible: ☐

164.
Today, find a use for the words "mastication", "pneumonoultramicro-scopicsilicovolcanocunios", "entheomania", and "Fred".

Mission accomplished: ☐

What happened?...

What did it feel like?...

How difficult was this mission:

A piece of cake: ☐ Hard: ☐ Impossible: ☐

165.
Don't sleep at all tonight.
Stay awake a whole 24 hours.

Mission accomplished: ☐

What happened?...

What did it feel like?...

How difficult was this mission:

A piece of cake: ☐ Hard: ☐ Impossible: ☐

166.
Today, wear double of everything. Two pairs of pants, two shirts, two pairs of underwear.

Mission accomplished: ☐

What happened?..

What did it feel like?..

How difficult was this mission:

A piece of cake: ☐ Hard: ☐ Impossible: ☐

167.
Make a baby cry.

Mission accomplished: ☐

What happened?..

What did it feel like?..

How difficult was this mission:

A piece of cake: ☐ Hard: ☐ Impossible: ☐

168.

Dump a friend over the phone. "Sorry, we can't be friends any more…".

Mission accomplished: ☒

What happened?....Tyler called Kylie !.......

What did it feel like?......FUNNY.............

How difficult was this mission:

A piece of cake: ☒ Hard: ☐ Impossible: ☐

169.

Carve your name in a tree.

Mission accomplished: ☐

What happened?...

What did it feel like?...

How difficult was this mission:

A piece of cake: ☐ Hard: ☐ Impossible: ☐

170.
Roll a ball down the street. Kiss the person who stops it.

Mission accomplished: ☐

What happened?..

What did it feel like?...

How difficult was this mission:

A piece of cake: ☐ Hard: ☐ Impossible: ☐

171.
Play "Four in a row" against yourself. Try to win.

Mission accomplished: ☐

What happened?..

What did it feel like?...

How difficult was this mission:

A piece of cake: ☐ Hard: ☐ Impossible: ☐

Write a poem!
Use the following words:
Bunny, lightblue, latex,
mother, waves
piedestal, fireworks, salute

172.

This morning, draw small, happy faces on all your fingers, and a big smiley face on your tummy.

Mission accomplished: ☐

What happened?...

What did it feel like?..

How difficult was this mission:

A piece of cake: ☐ Hard: ☐ Impossible: ☐

173.

Today, only eat food of one color - your choice.

Mission accomplished: ☐

What happened?...

What did it feel like?..

How difficult was this mission:

A piece of cake: ☐ Hard: ☐ Impossible: ☐

174.
Apply for a job above your ability.... WAY above your ability, like neurophysicist or brain surgeon.

Mission accomplished: ☐

What happened?..

What did it feel like?...

How difficult was this mission:

A piece of cake: ☐ Hard: ☐ Impossible: ☐

175.
Catch a cold.

Mission accomplished: ☐

What happened?..

What did it feel like?...

How difficult was this mission:

A piece of cake: ☐ Hard: ☐ Impossible: ☐

176.
Write down what you would do if you only had one day to live.

Mission accomplished: ☐

What happened?...

What did it feel like?...

How difficult was this mission:

A piece of cake: ☐ Hard: ☐ Impossible: ☐

177.
Bury and hide something valuable.

Mission accomplished: ☐

What happened?...

What did it feel like?...

How difficult was this mission:

A piece of cake: ☐ Hard: ☐ Impossible: ☐

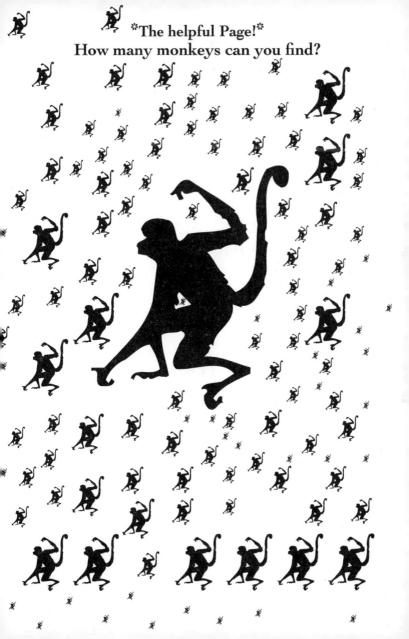

The helpful Page!
How many monkeys can you find?

178.
Go to your local supermarket and participate in all the contests and product giveaways you can find.

Mission accomplished: ☐

What happened?...

What did it feel like?...

How difficult was this mission:

A piece of cake: ☐ Hard: ☐ Impossible: ☐

179.
Ride a horse.

Mission accomplished: ☐

What happened?...

What did it feel like?...

How difficult was this mission:

A piece of cake: ☐ Hard: ☐ Impossible: ☐

180.

Ask people on the street for change. Collect at least $ 5. Give it to charity or a homeless.

Mission accomplished: ☐

What happened?...

What did it feel like?...

How difficult was this mission:

A piece of cake: ☐ Hard: ☐ Impossible: ☐

181.

All day today, present youself as "Steve" when answering the phone.

Mission accomplished: ☐

What happened?...

What did it feel like?...

How difficult was this mission:

A piece of cake: ☐ Hard: ☐ Impossible: ☐

182.
All day today, wear shoes at least one size too small.

Mission accomplished: ☐

What happened?..

What did it feel like?..

How difficult was this mission:

A piece of cake: ☐ Hard: ☐ Impossible: ☐

183.
Break at least two of the ten commandments.

Mission accomplished: ☐

What happened?..

What did it feel like?..

How difficult was this mission:

A piece of cake: ☐ Hard: ☐ Impossible: ☐

-walk Through a drive-*The helpful Page!*
Through and order a number 8

Make up your own missions and send them to:
info@nicotext.com

184.
Learn how to tie
a Bimini Twist knot.

Mission accomplished: ☐

What happened?..

What did it feel like?..

How difficult was this mission:

A piece of cake: ☐ Hard: ☐ Impossible: ☐

185.
Write down your famous last words.

Mission accomplished: ☐

What happened?..

What did it feel like?..

How difficult was this mission:

A piece of cake: ☐ Hard: ☐ Impossible: ☐

186.

Follow these directions: walk straight for 10 minutes, turn left.
Walk straight again, then take the first left and walk straight for 15 minutes.
Cross the nearest bridge and walk straight for 10 minutes.
Get on a bus and get off after four stops.
Sit down and think of a great business idea.
Write it down.

Mission accomplished: ☐

What happened?...

What did it feel like?...

How difficult was this mission:

A piece of cake: ☐ Hard: ☐ Impossible: ☐

187.
Hitchhike or pick up a hitchhiker.

Mission accomplished: ☐

What happened?..

What did it feel like?..

How difficult was this mission:

A piece of cake: ☐ Hard: ☐ Impossible: ☐

188.
Arrange a party with the theme "Knights in shining armour".

Mission accomplished: ☐

What happened?..

What did it feel like?..

How difficult was this mission:

A piece of cake: ☐ Hard: ☐ Impossible: ☐

189.
Get a stranger to tell you their life story.

Mission accomplished: ☐

What happened?..

What did it feel like?..

How difficult was this mission:

A piece of cake: ☐ Hard: ☐ Impossible: ☐

190.
Sing a song to a child.

Mission accomplished: ☐

What happened?..

What did it feel like?..

How difficult was this mission:

A piece of cake: ☐ Hard: ☐ Impossible: ☐

191.

Make a pyramid of crackers in the middle of the sidewalk. If people look at you funny, nod knowingly and say

"oh, yes, it's true.
The prophecy will come to pass."

Carefully take the top cracker and munch it slowly.

Mission accomplished: ☐

What happened?..

What did it feel like?..

How difficult was this mission:

A piece of cake: ☐ Hard: ☐ Impossible: ☐

Make your own movie quote.
Use these words:

God
War
Dog
Dead
Kiss
Bitch
Kill
Love
Bible
Badass
Motorcycle
Bust out

192.
Write a poem and hand it to a random person on the street.

Mission accomplished: ☐

What happened?..

What did it feel like?...

How difficult was this mission:

A piece of cake: ☐ Hard: ☐ Impossible: ☐

193.
Buy a homeless person lunch.

Mission accomplished: ☐

What happened?..

What did it feel like?...

How difficult was this mission:

A piece of cake: ☐ Hard: ☐ Impossible: ☐

194.
Google a lost love.

Mission accomplished: ☐

What happened?...

What did it feel like?..

How difficult was this mission:

A piece of cake: ☐ Hard: ☐ Impossible: ☐

195.
Invent a spouse, if you don't have one. Make them dinner.

Mission accomplished: ☐

What happened?...

What did it feel like?..

How difficult was this mission:

A piece of cake: ☐ Hard: ☐ Impossible: ☐

196.
Sing your voice mail messages today.

Mission accomplished: ☐

What happened?..

What did it feel like?..

How difficult was this mission:

A piece of cake: ☐ Hard: ☐ Impossible: ☐

197.
Pick a map of your area, close your eyes, and point randomly to a spot on the map. Travel there today.

Mission accomplished: ☐

What happened?..

What did it feel like?..

How difficult was this mission:

A piece of cake: ☐ Hard: ☐ Impossible: ☐

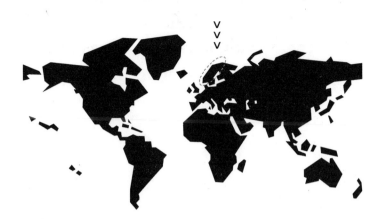

Learn Swedish!

Hello, my name is:	Hej, jag heter
You look mighty fine:	Du är söt!
How much for the little girls?:	Vad kostar småflickorna?
Scratch my back, will you:	Kan du klia mig på ryggen?
Hold that elevator!:	Håll hissen!
Don't step in that!:	Se upp så du inte trampar i det där!
Thank you for the lovely dinner:	Tack så mycket för maten!
Fill her up:	Full tank tack!
Wipe you feet on the rythm rug:	Torka fötterna på rytmmattan.

The helpful Page!

198.
Wear suspenders backwards, and go to church.

Mission accomplished: ☐

What happened?..

What did it feel like?..

How difficult was this mission:

A piece of cake: ☐ Hard: ☐ Impossible: ☐

199.
Attend the funeral of a complete stranger.

Mission accomplished: ☐

What happened?..

What did it feel like?..

How difficult was this mission:

A piece of cake: ☐ Hard: ☐ Impossible: ☐

200.
Wear sweatpants to a fancy restaurant.

Mission accomplished: ☐

What happened?..

What did it feel like?..

How difficult was this mission:

A piece of cake: ☐ Hard: ☐ Impossible: ☐

201.
Enter a karaoke contest.

Mission accomplished: ☐

What happened?..

What did it feel like?..

How difficult was this mission:

A piece of cake: ☐ Hard: ☐ Impossible: ☐

202.
Make a tin foil hat and wear it all day, along with an Area 51 t-shirt.

Mission accomplished: ☐

What happened?..

What did it feel like?..

How difficult was this mission:

A piece of cake: ☐ Hard: ☐ Impossible: ☐

203.
Change your ringtone after every call you receive today.

Mission accomplished: ☐

What happened?..

What did it feel like?..

How difficult was this mission:

A piece of cake: ☐ Hard: ☐ Impossible: ☐

Before I die I want to:

- [] Know if Elvis is still alive
- [] Climb Mount Everest
- [] Compete in the Olympics
- [] Have a threesome
- [] Jump parashute
- [] Meet Jesus
- [] Shoot a moose
- [] Be a hero
- [] Win a million
- [] Be on TV
- [] Star in a movie
- [] Travel the world
- [] Get married
- [] Write a book
- [] Have a baby

204.
Inflate 10 balloons in a row.
Stop if you start to feel dizzy.

Mission accomplished: ☐

What happened?...

What did it feel like?...

How difficult was this mission:

A piece of cake: ☐ Hard: ☐ Impossible: ☐

205.
Go a whole day without using your
watch or knowing what time it is.

Mission accomplished: ☐

What happened?...

What did it feel like?...

How difficult was this mission:

A piece of cake: ☐ Hard: ☐ Impossible: ☐

206.
Take 15 minutes and think about what people in other parts of the world are doing right now.

Mission accomplished: ☐

What happened?...

What did it feel like?...

How difficult was this mission:

A piece of cake: ☐ Hard: ☐ Impossible: ☐

207.
Play with a child.

Mission accomplished: ☐

What happened?...

What did it feel like?...

How difficult was this mission:

A piece of cake: ☐ Hard: ☐ Impossible: ☐

208.

Make a child belive that Santa Claus is fake, make an adult belive that Santa Claus really excist.

Mission accomplished: ☐

What happened?..

What did it feel like?..

How difficult was this mission:

A piece of cake: ☐ Hard: ☐ Impossible: ☐

209.

Shoot hoops in your head. Picture yourself shooting, and scoring, 10 consecutive times. If you miss, start over.

Mission accomplished: ☐

What happened?..

What did it feel like?..

How difficult was this mission:

A piece of cake: ☐ Hard: ☐ Impossible: ☐

Tic-tac-toe

-a hard core game!

210.
Tell a stranger he/she is beautiful.

Mission accomplished: ☐

What happened?..

What did it feel like?...

How difficult was this mission:

A piece of cake: ☐ Hard: ☐ Impossible: ☐

211.
Record your own voice and listen to it until you're comfortable with it.

Mission accomplished: ☐

What happened?..

What did it feel like?...

How difficult was this mission:

A piece of cake: ☐ Hard: ☐ Impossible: ☐

Chocolate Chip Cookies

1 cup all-purpose flour
1/2 teaspoon baking soda
1/2 teaspoon salt
1/2 cup butter
1/2 cup brown sugar
1/3 cup sugar
1 large egg
1/2 teaspoon vanilla extract
1 cup (6 ounces) chocolate chips
1/2 cup chopped walnuts

Heat the oven to 375 degrees F (190 degrees C).
Combine flour, baking soda and salt in a small bowl.
In a large bowl, mix butter, brown sugar, sugar, egg and vanilla until creamy. Add flour mixture and stir. Then add chocolate chips and walnuts. Dop walnut-sized balls of dough onto a baking sheet.
Bake until golden, for 9 to 11 minutes.

Cookies

212.
Today, only use cold water. Showering, wahsing your hands, doing dishes etc.

Mission accomplished: ☐

What happened?..

What did it feel like?..

How difficult was this mission:

A piece of cake: ☐ Hard: ☐ Impossible: ☐

213.
Watch someone sleeping.

Mission accomplished: ☐

What happened?..

What did it feel like?..

How difficult was this mission:

A piece of cake: ☐ Hard: ☐ Impossible: ☐

214.
Today, only eat blue food.

Mission accomplished: ☐

What happened?..

What did it feel like?..

How difficult was this mission:

A piece of cake: ☐ Hard: ☐ Impossible: ☐

215.
Today, watch TV with
the sound turned off.

Mission accomplished: ☐

What happened?..

What did it feel like?..

How difficult was this mission:

A piece of cake: ☐ Hard: ☐ Impossible: ☐

216.
Pull out a hair on a stranger.

Mission accomplished: ☐

What happened?..

What did it feel like?..

How difficult was this mission:

A piece of cake: ☐ Hard: ☐ Impossible: ☐

217.
Count to a thousand.

Mission accomplished: ☐

What happened?..

What did it feel like?..

How difficult was this mission:

A piece of cake: ☐ Hard: ☐ Impossible: ☐

Tonga Ilands national anthem
Learn it by heart so the next time
you're on Tonga you can impress the locals

TONGAN LYRICS:
'E 'Otua Mafimafi,
Ko ho mau 'Eiki Koe,
Ko Koe Koe fa la la 'anga,
Mo ia 'ofa ki Tonga;
'Afio hifo 'emau lotu,
'Aia 'oku mau fai ni,
Mo Ke tali homau loto,
'O mala'i 'a Tupou.

ENGLISH TRANSLATION:
Oh Almighty God above,
Thou art our Lord and sure defence,
In our goodness we do trust Thee
And our Tonga Thou dost love;
Hear our prayer, for though unseen
We know that Thou hast blessed our land;
Grant our earnest supplication,
Guard and save Tupou our King.

Words by: Prince Uelingatoni Ngu Tupoumalohi
In use: 1874- Music by: Karl Gustavus Schmitt

The helpful Page!

More from nicotext

Ultra Modern History
The History of Sitcoms, Porn, Microwaves and Skateboards
ISBN: 91-85449-07-5, Humor/Pop Culture, $ 9.95/Paper
Let the old folks read the old history books because this is
history for the new generation. Who cares which king lived when
and what church burned down this or that date? Who cares what
year a certain war started, who won and why the hell they were
fighting in the first place? I don't, and you probably don't either.
Time has come for a change. I want to know when internet first
started and who the heck invented it! I want to know what year
icecream, Seinfeld and sunglasses were invented. I want to
know when porn got huge and tennis shoes became popular.

The Student Cookbook
200 Cheap and Easy Recipes for Food, Drinks and Snacks
91-85449-11-3, Humor/Cooking, $ 9.95/Paper
A hungry student is a bad student. That's why we've put together
a cookbook perfect for anyone in school. The rest of the cook-
books out there are written by adults--you know, old people like
mom and dad, or your teachers. Not this book. It's written by and
for students and it contains everything you could possibly wish
for in a cookbook. Besides all the obvious stuff, like cheap, tasty,
nutritious and easy-to-make recipes for foods, drinks and snacks,
it also contains weird facts about food, food history, movie quotes
and general facts of life--all with a reference to each recipe!

The Macho Man's Drinkbook
91-85449-08-3, Humor/Cooking, $ 19.95/Paper
The Macho Man's Drinkbook contains more than 150 recipes of
the most popular drinks and cocktails. And because all Macho
Men knows that booze and naked chicks go great together, drink
recipes are accompanied by 60 color photos of exotic and
beautiful, topless women.
Two fine things combined in one book! Just the way every
Macho Man wants it.

More from nicotext

BLA BLA - 600 Incredibly Useless Facts
Something to Talk About When You Have Nothing else to Say
91-974882-1-6, Humor, $ 9.95/Paper
A Know-It-All's Handbook
Everyone needs something to blurt out during uncomfortable
silences and ice-breaker moments. This fascinating handbook
of hilarious, arcane and bizarre tidbits will make its bearer a hit
at party conversation and trivia contests.

Confessions
Shameful Secrets of Everyday People
91-974396-6-5, Humor, $ 9.95/Paper
Eavesdropping in the Confessional.
Like being a fly on the wall in any church confessional, these
incredible real online admissions of people's darkest secrets
are alternately disturbing, whimsical and hilarious. Sure to spark
interesting conversations, this is the perfect therapeutic gift to
share with friends and loved ones (and perhaps detested
enemies, with certain confessions circled in red and
"I know your secret" handwritten nearby).

Cult Movie Quote Book
91-974396-3-O, Humor/Film, $ 9.95/Paper
A Film Buff's Dictionary of Classic Lines.
Over 700 memorable, provocative, hilarious and thought
provoking quotes fill this fascinating guide, a kind of dictionary
for movie quote buffs. Going beyond the old standards such as
"Here's Looking at You Kid," this handbook pulls quotes from a
surprisingly eclectic variety of global cinematic gems, and will
have even the most diehard movie buffs frantic to place the line
with the film.

More from nicotext

Dirty Movie Quote Book
91-974396-9-X, Humor/Film, $ 9.95/Paper
Saucy Sayings of Cinema.
With over 700 saucy, sexy quotes from the funniest and most
sordid films ever produced. A movie quiz game in a book.
An excellent source of fresh pick-up or put-down lines,
this titillating guide is sure to put anyone in the mood for love.

The Pet Cookbook
Have your best friend for dinner
91-974883-4-8, Humor/Cooking, $ 14.95/Paper
Domesticated Delicacies from Around the World
On a global scale, one man's pet is another man's supper,
and this wild cookbook shares the best recipes from around the
world on how to prepare those delectable little dishes from the
domesticated animal kingdom. Scorpion Soup with a Sting, Pony
'n' Pepperoni Pizza, Parrot Piroge, and Goldfish Tortilla Wrap are
just a few samples of the eclectic world cuisine within.
Decidedly not for vegetarians.
*No animals were hurt during the making of this book.

The World's Coolest Baby Names
A Name Book for the 21st Century Parent
91-974883-1-3, Pop Culture, $ 7.95/Paper
A perfect name guide to spice up any baby shower name game.
Baby names aren't handed down anymore, and the coolest
names are as much from pop culture as from the Bible. Hybrid
names from popular and arcane sources in literature, television,
and film create some very memorable name combinations. In-
cludes the amusing trivia behind the names' origins and is sure
to spark scads of arguments in expectant families everywhere!

More from nicotext

The Pornstar Name Book
The Dirtiest Names on the Planet
91-974883-2-1, Humor, $ 14.95/Paper
The coolest hardcore names in the business
Rename your lover, or your pet, your car or the stupid
person at work in the nom de plume of a pornstar!
Here are the coolest names in the entire X-rated business,
along with tons of fun porn and sex trivia. Read it for at laugh
or get ideas for creating your own dirty nicknames.
The Pornstar Name Book also contains a music CD, Porn Lounge
Music, which is perfect to put you in the right mood for doing what
porn stars are paid to do.

The Bible About My Friends
91-974396-4-9, Humor, $ 9.95/Paper
Things You've Always Wanted to Know But Have Been too
Scared to Ask. This book is about your friends and everything
you've always wanted to know about them.
featuring simple, funny, entertaining questions for your very best
friends to answer. These are questions about who they really are,
about their dreams, hopes, plans and, not least, their secrets.
You know, things you've always wanted to know about them but
have been to scared to ask. This book will bring out the worst and
the best about those you thought you knew.
Together you will laugh at the answers for years to come.
That is, if you're still friends...

NICOTEXT wants YOU!

This is what I liked with this book:

This is what I didn't like with this book:

I want a catalogue (your adress) :

I want to receive an email now and then (your email):

My friend wants a catalogue (friends adress):

I want a million dollars: ☐ yes ☐ no

Next time, why don't you make a book about: